The Basic Step

1. **Dots**
2. **String**
3. **Tangles**
4. **Shade** (pg. 9)
5. **Initials**

3. **Tangles**- Switch to your pen and fill each section of the String with Tangles.

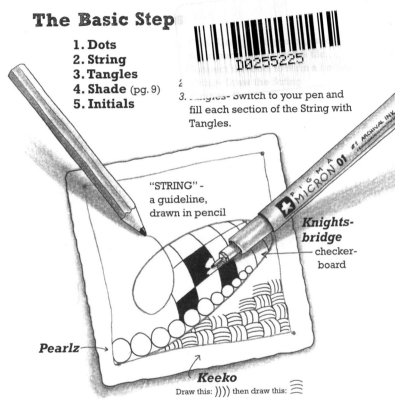

"STRING" -
a guideline,
drawn in pencil

Knights-bridge - checker-board

Pearlz

Keeko
Draw this:)))) then draw this: ≋

Tip: Be sure to turn your tile as you draw.
There is no right-side-up in Zentangle.
Allow yourself to be surprised by what appears.

Printemps

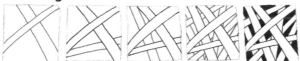

Tip: Notice how tangles build backwards. Each addition is drawn *behind* the first to give the illusion of depth.

Hollibaugh

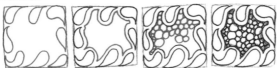

Ennies

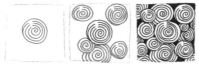

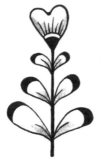

Tip: "Zentangle" is a noun, not a verb.
Don't say:
 "I Zentangled my bathroom floor."
Say:
 "I tangled my bathroom floor!"

Other things to say:
 "I need to create a Zentangle, right now!"
 "Sorry, I didn't hear you.
 I was busy tangling."

What is Zentangle®?

Zentangle is meditation achieved through pattern-making. A Zentangle is a complicated looking drawing that is built one line at a time. Simple tangles, or patterns, are combined in an unplanned way that grows and changes in amazing directions. With your mind engaged in drawing, your body relaxes. Anxiety and stress move to the back burner. Often, new insights are uncovered along with a sense of confidence in your creative abilities.

Zentangle was developed by artists Rick Roberts and Maria Thomas as a tool to be used by artists and non-artists alike. For information about the process, instructions, and lots of beautiful examples, be sure to visit their website at **www.zentangle.com.**

TOOLS - All you really need:

- **pencil**
Any No. 2 pencil will do.
Find one without an
eraser so you won't be
tempted to "fix" your art.
- **Pigma Micron 01 black pen**
With pigmented, archival,
non-bleeding ink, these
0.25mm pens are a
dream to draw with.

an original

☐ zentangle.

zentangle.com
Copyright © 2004 Zentangle, Inc. All Rights Reserved.

- **Zentangle tiles**
These 3.5" square
tiles are made from
fine Italian paper. Once
you tangle on these, you'll
never be happy with cardstock
(or note-paper!) again.
Watercolor paper can make a
nice surface to tangle on too,
but be sure to cut it down to a
manageable and portable size.

Tip: When first learning
Zentangle, stick to just
these tools - keep it simple.
The point is to focus your
mind on the lines and
patterns and not worry
about what pen to use.

AlphaTangle

A Truly Tangled Alphabet

by Sandy Steen Bartholomew

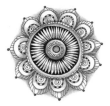

AlphaTangle Copyright © 2009
by Sandra Steen Bartholomew

© 2011 DESIGN ORIGINALS by Suzanne McNeill
2425 Cullen St,
Fort Worth, Texas 76107, U.S.A., 817-877-0067
www.d-originals.com

Author's Note: In other words, you may not copy, by any means, any pages from this book. But you should feel free to be inspired by the tangles and ideas, and to apply them to your own work. If you teach, please give credit. Thanks!

Welcome to the best in-your-pocket reference for Zentangle®!

In 2009, I self-published an adorably teeny, 4-inch square book of tangled alphabet letters.

AlphaTangle was intended to serve as inspiration for the small, but growing group of artists who practiced Zentangle. *AlphaTangle* was the first book published on Zentangle and a few thousand copies have found their way around the world!

In your hands, you now hold the new and improved, revised and updated, Design Originals edition of *AlphaTangle*! This gem of a book is still small in size and packed with tangles. So, whether you are traveling, waiting at the doctor's office, picking up kids at school, visiting with friends or relaxing on the sofa - *AlphaTangle* is the perfect reference to jump-start your creativity. A nice addition to any letter-lover's library, *AlphaTangle* now also includes the basics for getting started with this relaxing, creative-confidence-boosting, and totally addictive art form called ***Zentangle!***

- Sandy Steen Bartholomew

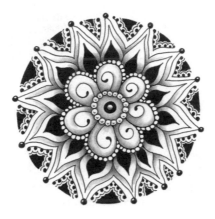

More Lingo:

"TANGLE" - a pattern taken from fashion, art, nature, observation, history... anywhere!

"ZENTANGLE" - the method of using pattern drawing to focus the mind. Also, the finished artwork.

"CZT"- a Certified Zentangle Teacher who has been intensely trained by Rick Roberts & Maria Thomas.

Final Steps:

4. Shading- Use your pencil to add shading and depth. Smudge with your finger or a paper stump.

5. Initial- As the final step, put your initials on the front of the tile, and sign and date the back.

(There is no top or bottom to a Zentangle, so the initials can go anywhere).

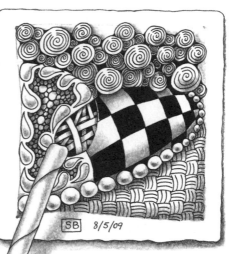

SB 8/5/09

Tip: It's fine if you prefer not to shade your Zentangles. Most of the tangles look great either way.

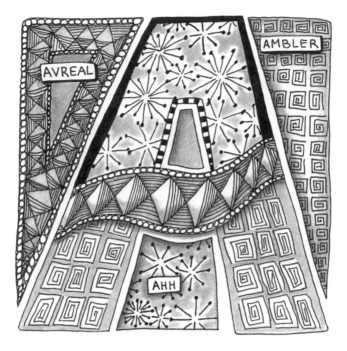

AVREAL

AMBLER

AHH

AlphaTangle 11

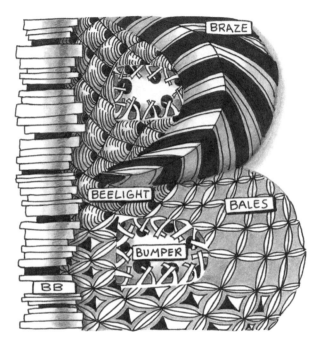

BRAZE

BEELIGHT

BALES

BUMPER

BB

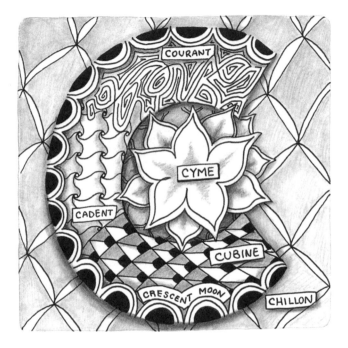

COURANT

CYME

CADENT

CUBINE

CRESCENT MOON

CHILLON

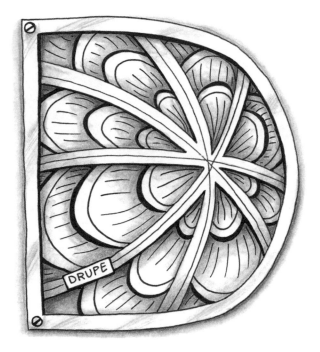

DRUPE

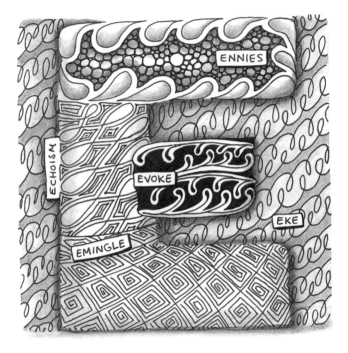

ENNIES

ECHOISM

EVOKE

EKE

EMINGLE

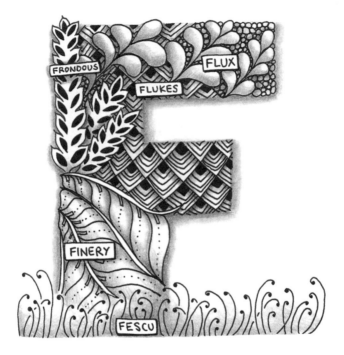

FRONDOUS · FLUKES · FLUX · FINERY · FESCU

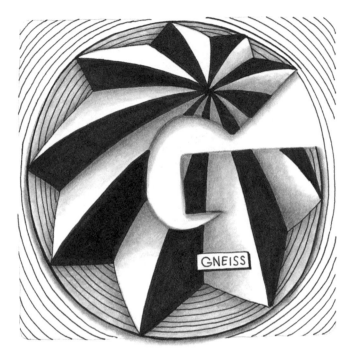

GNEISS

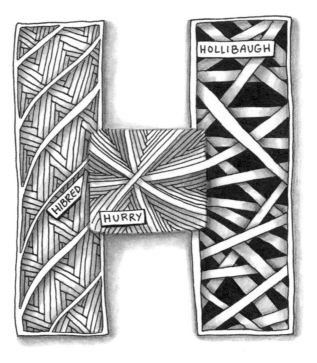

HOLLIBAUGH

HIBRED

HURRY

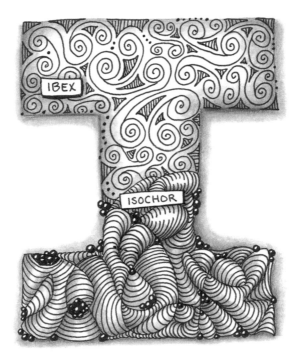

IBEX

ISOCHOR

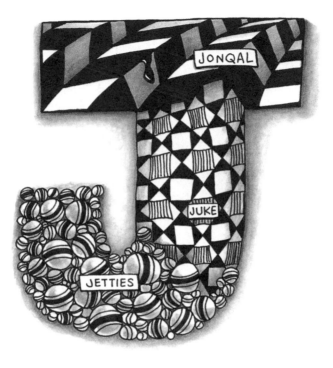

JONQAL

JUKE

JETTIES

AlphaTangle 29

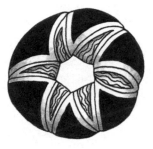

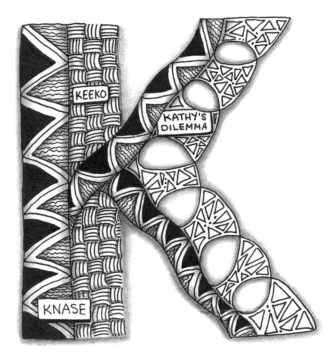

KEEKO

KATHY'S DILEMMA

KNASE

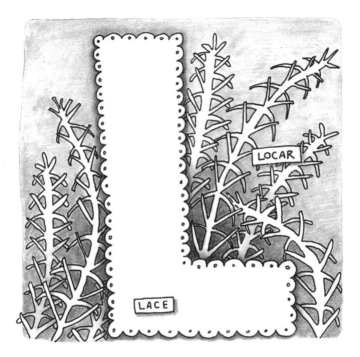

LOCAR

LACE

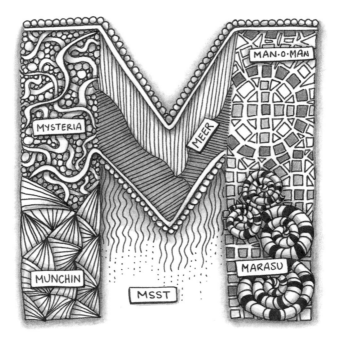

MYSTERIA

MAN·O·MAN

MEER

MUNCHIN

MARASU

MSST

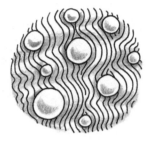

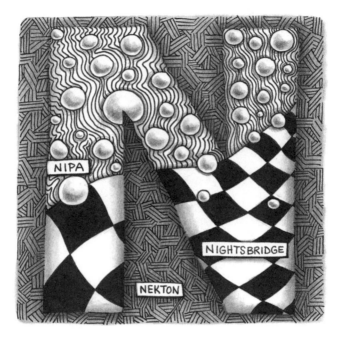

NIPA

NEKTON

NIGHTSBRIDGE

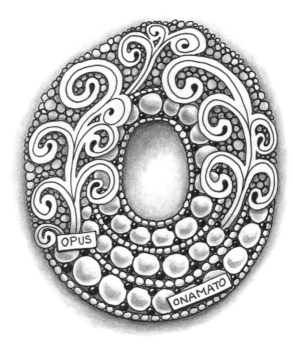

OPUS

ONAMATO

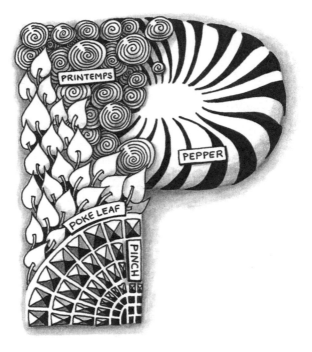

PRINTEMPS

PEPPER

POKE LEAF

PINCH

AlphaTangle 41

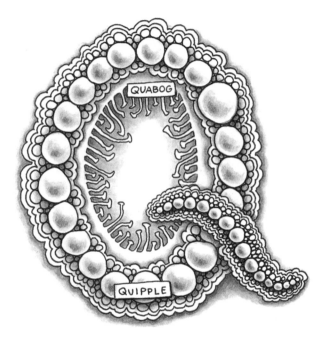

QUABOG

QUIPPLE

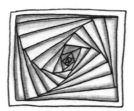

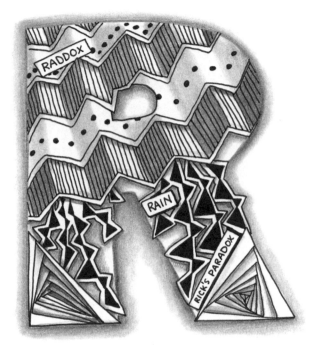

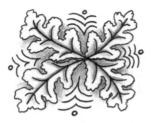

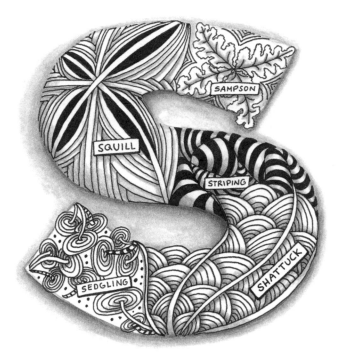

SAMPSON

SQUILL

STRIPING

SEDGLING

SHATTUCK

AlphaTangle 47

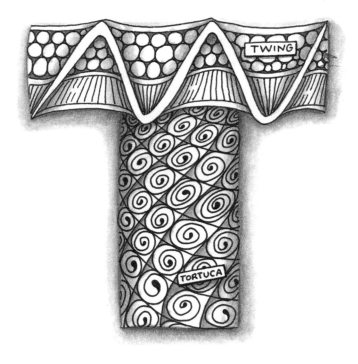

TWING

TORTUCA

AlphaTangle 49

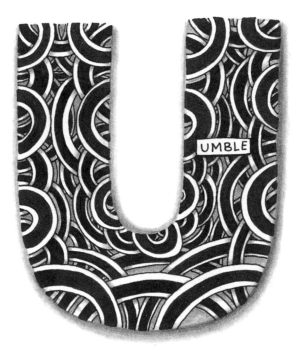

UMBLE

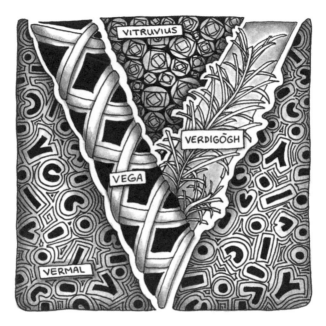

VITRUVIUS

VERDIGŌGH

VEGA

VERMAL

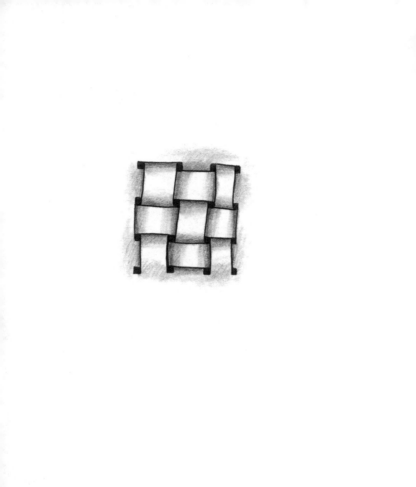

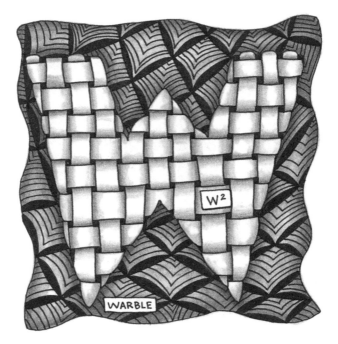

WARBLE

W^2

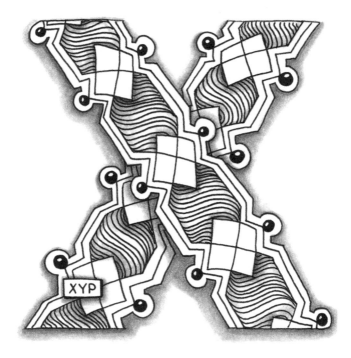

XYP

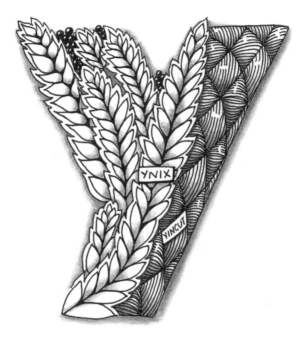

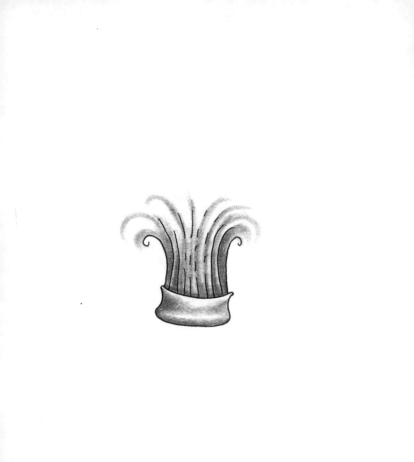

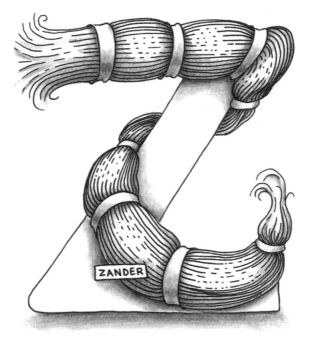

ZANDER

Write to me at: ***beezink@tds.net***

Sandy Steen Bartholomew

is an author, illustrator, mixed-media artist, rubber stamp designer, and Certified Zentangle Teacher. A graduate of Rhode Island School of Design, she runs Beez Ink Studio and Wingdoodle, her creativity general store.

Her images are whimsical, colorful, bi-polar, anachronistic, silly, creative, and "pwitty." Inspirations include: ancient civilizations, rusty things, children's books, her kids' artwork, toys, patterns, architecture and cereal boxes.

Sandy lives in a tangled, mixed-media house in New Hampshire with her two children and a cat.

To learn more about her art, articles and Zentangles, visit her website, **www.beezinkstudio.com**.

Totally Tangled -
Zentangle® and Beyond!

Want to learn Zentangle®?
Want to learn MORE? Get the
basics plus tips on designing
your own tangles. This book is
filled with 52 pages of great
ideas, artwork, tips and a
gazillion new Tangles. Get
inspiration from 12 artists -
all completely addicted to
this amazing artform.

Yoga For Your Brain -
A Zentangle® Workout

Don't let the calm girl fool you.
This much anticipated sequel
to *TOTALLY TANGLED* is just
as tangled! Inside, the pages
are jam-packed with lots of
Zentangle® ideas, projects,
tips, and more than 60 new
Tangle patterns with instructions!

For more of Sandy's books, visit
your favorite local or online bookstore.
Or visit the Design Originals website:
www.d-originals.com